EASEL SERIES

Acrylics

A new way to learn how to paint

BARRON'S

This book is designed to make it easy for readers to learn how to paint with acrylics. The book's pages are read from top to bottom, rather than from left to right, and this means it can be folded in half and turned into an easel.

After a short introduction to the basic techniques of acrylic painting, this book suggests seven exercises to put what we have learned into practice. Each of the exercises is broken down into steps that simply and clearly explain in full detail how to execute each step on the even-numbered pages and show the end result of this step on the odd-numbered pages. In turn, we can use this as a model on our easel.

This novel and practical format makes it easier to see each of the stages of each exercise. At the same time, it leaves readers' hands free to put into practice what they have learned and enjoy painting.

Acrylic painting techniques

Watercolor painting

When acrylic paint is diluted with a large amount of water it can give results that are similar to those of watercolors, but not the same. Watercolors are brighter and easier to use with a large amount of water. If we are painting on canvas, the lack of absorbency of the support forces us to pick up the excess acrylic paint with a dry brush until the painted area is stabilized. If we are painting on paper, its greater absorbency requires us to use more water, which can cause the accumulation of puddles. Still, the watercolor technique with acrylics is an interesting possibility for simple subjects that do not require details or a lot of retouching.

These four patches of color look like watercolors. They are transparent and delicate. They are painted on canvas, and it was necessary to wait a long time for each color to dry before painting the next one. The canvas barely absorbs the water and the colors dry only through evaporation.

This layer of color is very thin and transparent.

Here you can see where the wet paint has run.

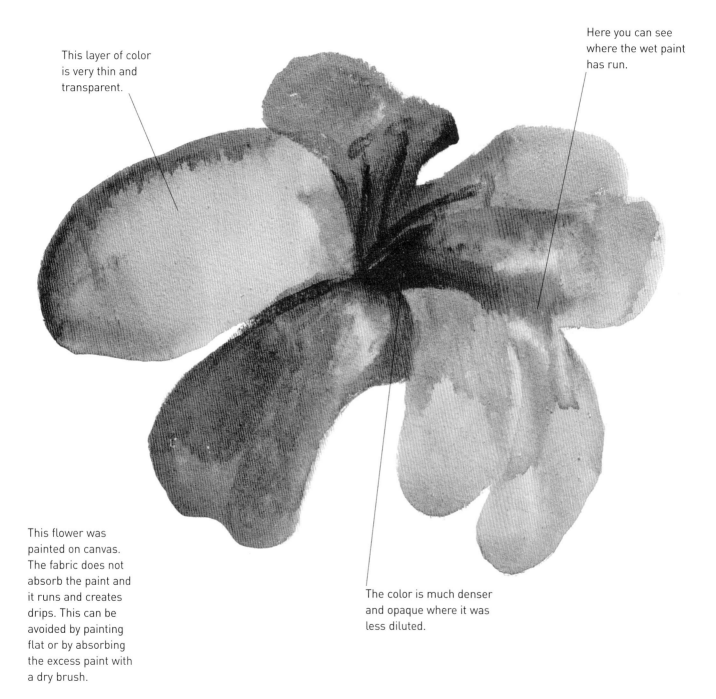

This flower was painted on canvas. The fabric does not absorb the paint and it runs and creates drips. This can be avoided by painting flat or by absorbing the excess paint with a dry brush.

The color is much denser and opaque where it was less diluted.

Flat and opaque color

This is the easiest and most obvious approach when painting with acrylic colors. This is done by painting with slightly diluted paint, with just enough water for the brush to glide easily across the support. If we paint over the area making brushstrokes in all directions, we can remove the brush marks and completely cover the background. If the paintbrush we are using is soft (with synthetic hair), the marks will be even less visible. This is how totally even, flat, and opaque colors are created. It is the ideal technique for creating a flat background color and also for painting in a graphic style with no complicated shading.

These clean, flat, and opaque colors with well-defined edges are very easy to achieve with acrylic paints. The paint is dense and diluted with just enough water to allow the brush to easily flow across the support.

If we add a little white to acrylic colors they will be totally opaque. We can witness this by studying the flesh tones of this face made with carmine paint mixed with white.

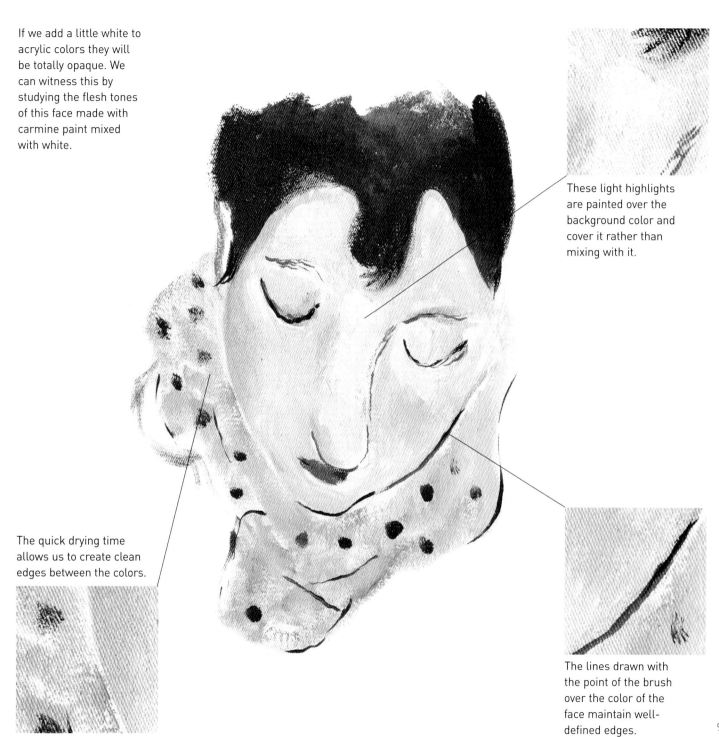

These light highlights are painted over the background color and cover it rather than mixing with it.

The quick drying time allows us to create clean edges between the colors.

The lines drawn with the point of the brush over the color of the face maintain well-defined edges.

9

Transparent and opaque

Should we work with a lot of water or a little water, transparent paint or opaque paint? The best course is to use both techniques and allow the techniques to contrast. Transparencies are useful for areas of brighter or more intense color, while the opaque colors are good for the more solid or rigid areas of the subject. The transparencies should be painted first because they can be painted over and made opaque very easily, but the reverse is not possible.

These sketches combine transparent and opaque colors. Some of them are transparent no matter how they are applied (very liquid or as an impasto); others are only transparent when they are very diluted.

These flowers were painted by combining transparent and opaque colors. All the details requiring light tones are transparent and the more solid ones are opaque.

These poppies were painted with very diluted and transparent carmine color.

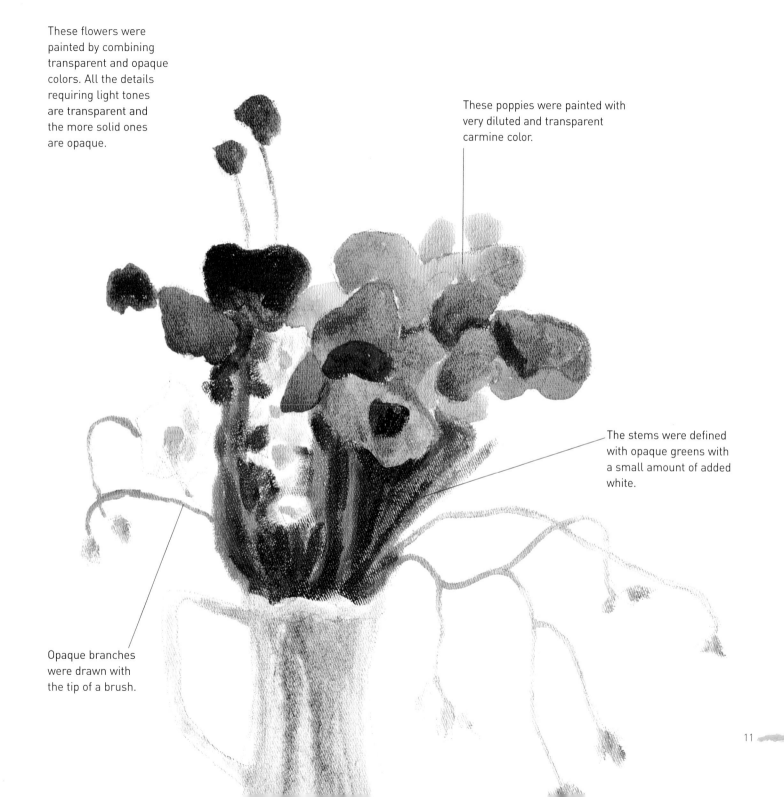

The stems were defined with opaque greens with a small amount of added white.

Opaque branches were drawn with the tip of a brush.

11

Mediums: blending colors

The mediums used in acrylic painting are equivalent to the oil in oil paint; it is the substance that binds the color. They are a milky white liquid that can be used for diluting the colors and slow their drying time, and make it easier to mix them with each other. The colors become slightly transparent and blend with each other easily. They are mainly used to create areas of broken color where the various tones weave together without completely mixing with each other. Mediums can be used instead of water or in combination with it. The colors illustrated below were painted with medium alone, without the addition of water.

Acrylic mediums add fluidity to the paint and create very interesting blended effects.

Here we have used medium to create the broken color on the teapot and all of the shading on it.

When mixed with acrylic medium, the color becomes slightly transparent and allows us to increase the number of shades of each tone.

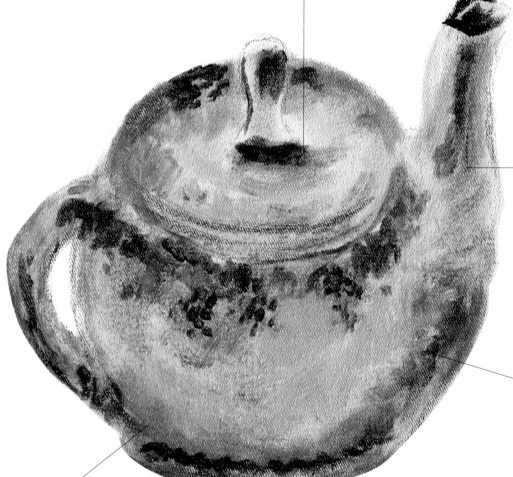

As the proportion of medium increases the color becomes increasingly lighter.

This shadow was created by overlaying green, yellow, and blue brushstrokes of paint mixed with medium.

The dark tones result from overlaying shades of blue diluted with acrylic medium.

Dry brush

The dry brush technique consists of painting with undiluted color, and without creating thick impastos. Applying a brushstroke of pure color on the support leaves a rough mark that illustrates the texture of the paper or canvas. Additional brushstrokes will only partially cover the first color and they will intensify the effect of the texture. Dry brush discourages transparencies, but not detail work. The outcome is better if we use hog bristle brushes, which are stiffer than synthetic brushes and they make a rougher brushstroke. We should work with short, light brushstrokes while being careful not to completely cover the underlying colors.

The yellows only partially cover the background and emphasize the texture of the canvas. The greens create a new layer of color that does not completely cover the yellows. The dry brush technique is based on this gradual accumulation of color.

The dry brush technique allows us to create lightly textured surfaces with very rich shading. The colors are always opaque. The brush should lightly sweep across the support and only partly mix the colors.

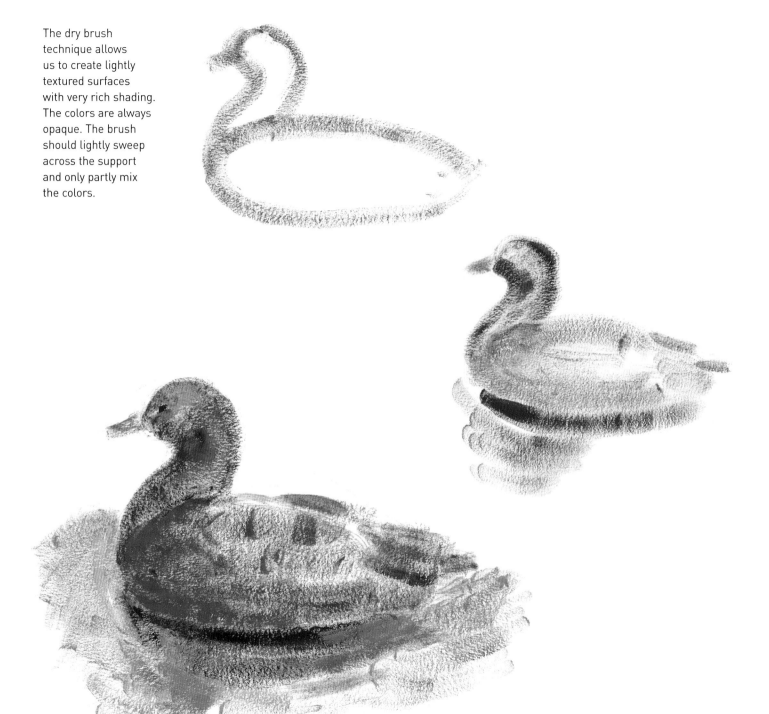

Impasto

It is very easy to create impastos with acrylic paint. It is possible to apply large quantities of color directly on the support with fat brushes or brushes heavily charged with paint, leaving heavy brush marks for all to see. But acrylic paints, because of the large amount of water in them, shrink when they dry and the texture is diminished. Therefore, it is necessary to use quite a bit more paint than we would use if painting with oils. As we work in this manner we must keep in mind that a superficial layer of paint will dry quickly while the thicker layers will take more time, so it is necessary to wait for the paint to dry completely before painting over it in cases where we wish to add more impasto.

The bristle marks of the brush used for these impastos are very visible now that the paint is dry, but they were even more evident when the paint was still wet. Acrylic paints shrink when they dry and this is an important factor to keep in mind when attempting to create good impastos.

Impastos force us to work without water and without mediums, although in the first stages of the work we can paint with diluted colors. The brushes should be very dry before applying the paint; if not the effects of the texture will not be as evident.

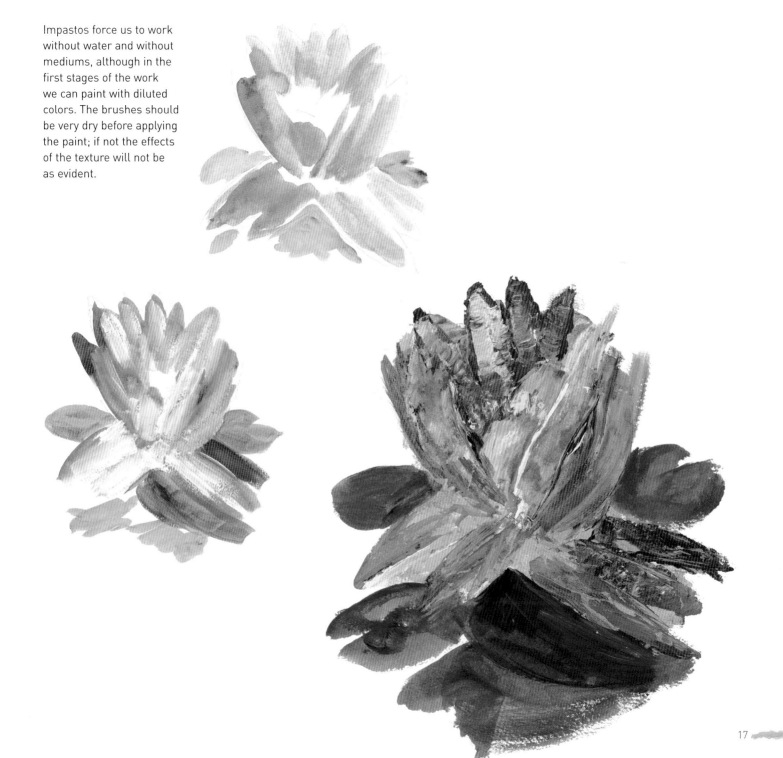

Masking

Masking refers to reserving a painted or unpainted area so that it will not be affected by later additions of paint. In acrylic painting, the masks, or reserves, are usually made with adhesive paper tape (masking tape). They are placed directly on the unpainted support or over dry paint. The tape covers the areas that we wish to reserve. These can be very useful for subjects where it is important to achieve graphic effects or very straight edges. The tape should be removed only after the paint is completely dry, unless we wish to have some irregularities in the edges.

Masking tape helps make straight edges. They also aid in creating colorist paintings with a graphic quality. The tape should be made of paper, never plastic.

Here we overlaid masking tape reserves at right angles to create the painting of the tablecloth. The different shades of the lightest blue were painted after the colors were completely dry.

We painted the yellows at the end over the dry paint. The solidity of the whites is greater than that of the yellow, which is why we can see the transparency of the color.

The weave of the fabric support creates a characteristic jagged effect along the masked area.

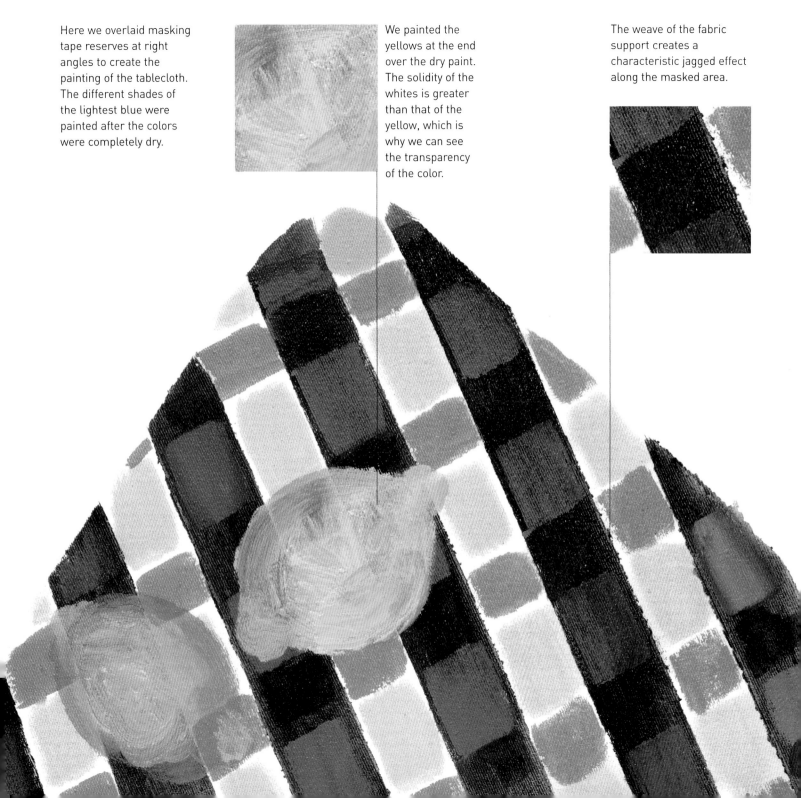

Acrylic painting processes

A rose: transparent and opaque

Chiaroscuro modeling is one of the simplest techniques in acrylic painting. Basically, it consists of gradating a color towards a darker shade using colors from the same range, or towards a lighter color using white. Black is not used here to keep the color from becoming too gray.

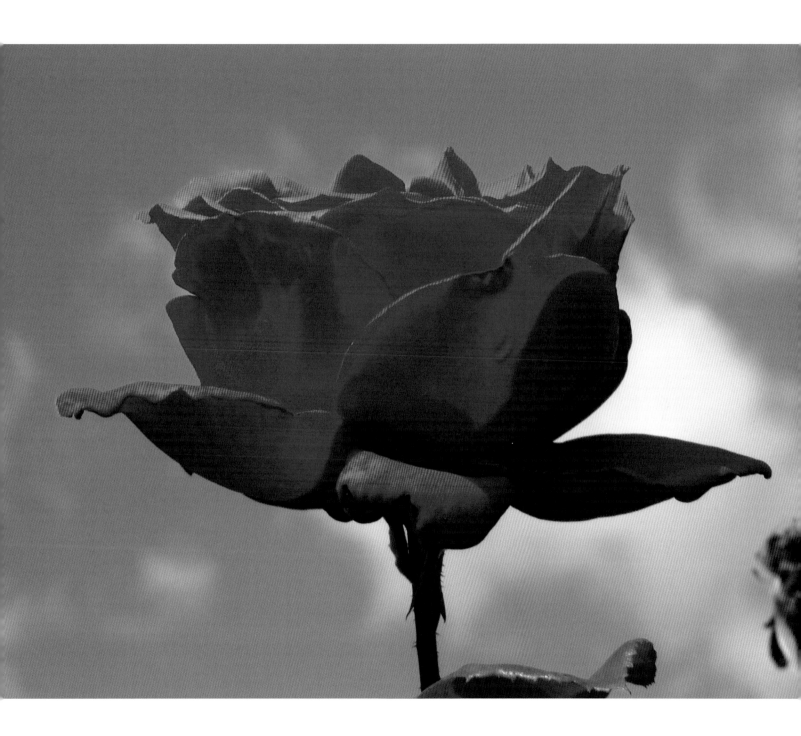

The required colors

We will use two reds: carmine and permanent red. Carmine is the more transparent of the two. In addition, we will use cadmium yellow, permanent green, and cobalt blue. Finally, we will add titanium white to the list.

carmine

permanent red

cobalt blue

permanent green

cadmium yellow

The drawing

This is a very simple representation of the outlines of the flower. Many of these lines will be lost during the painting, but it is very important to keep them in mind to calculate the different applications of color. It was drawn with a medium hard pencil.

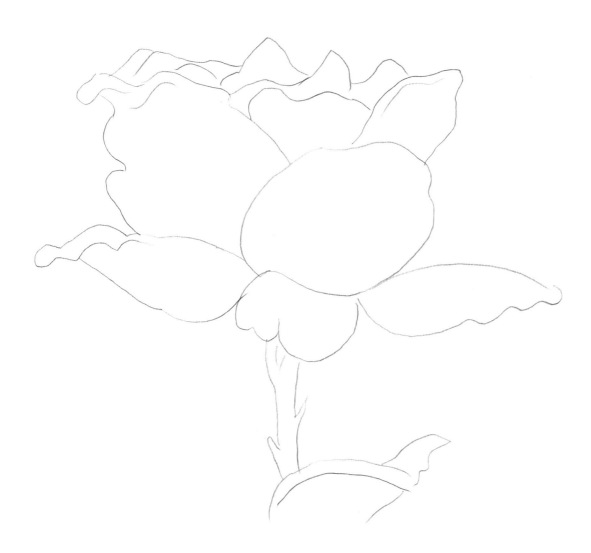

From petal to petal

We will begin with the transparent colors, painting each one of the largest petals without worrying, for now, about the shadows. We will work with a flat synthetic hair paintbrush.

1 | The typical technique is to make a first stroke of carmine along the lower edge of the drawing.

2 | Immediately after that we charge the brush with more water and spread the paint to create a transparent color that we carry to the edges of the drawing.

3 | We paint the darkest petals with undiluted permanent red, making a flat opaque shape.

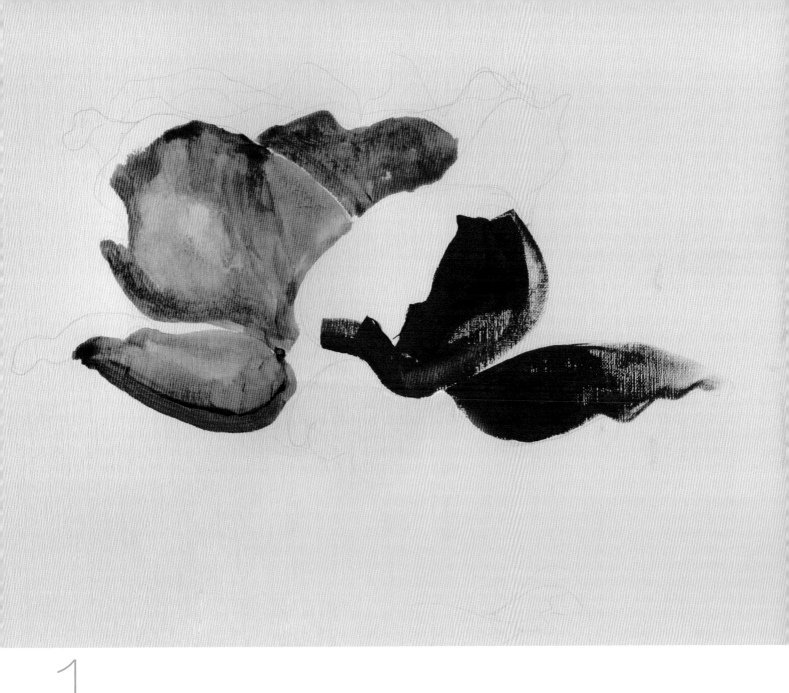

1 By simply combining transparent and opaque petals we create a
first effect of relief and chiaroscuro.

The darkest shadows

After painting the entire flower with the same color in its transparent and opaque variations, we now use the same color darkened to create the deepest shadows.

1 | A mixture of carmine and blue make a dark purple that is quite opaque. We use it to paint flat shadows on the petals receiving the least light, while always respecting the outlines.

2 | Mixing permanent red with the purple creates an intermediate tone that we use to shade the transition from the light tone to the dark.

3 | This petal is almost completely in shadow. We paint it with the unmixed purple, covering the whole silhouette except at the far end.

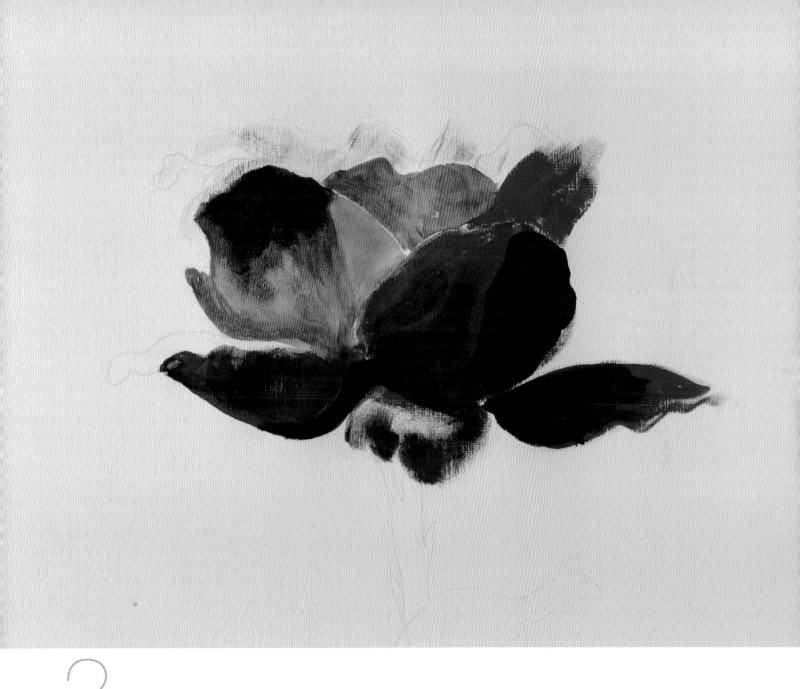

2 All the overpainting was done after the base color was completely dry to avoid unwanted mixing.

The stem and the sky

Now we turn to the least difficult part of the work. The stem is very easy to resolve, and the sky can be worked freely because it does not have any significant detail. We will use a medium hog bristle brush.

1 | The colors of the stem are a mix of green and yellow, in the lightest parts, and of green and blue in the darkest. The color is opaque and we can follow the drawing to complete this part of the work.

3 | The outlines of the flower are painted with the blue mixed with some white.

2 | We paint the clouds with a very light blue. For this we mix the blue with white and dilute it heavily before applying it. Spread the paint well so it will mix with the darkest parts. The brushstrokes can be left visible.

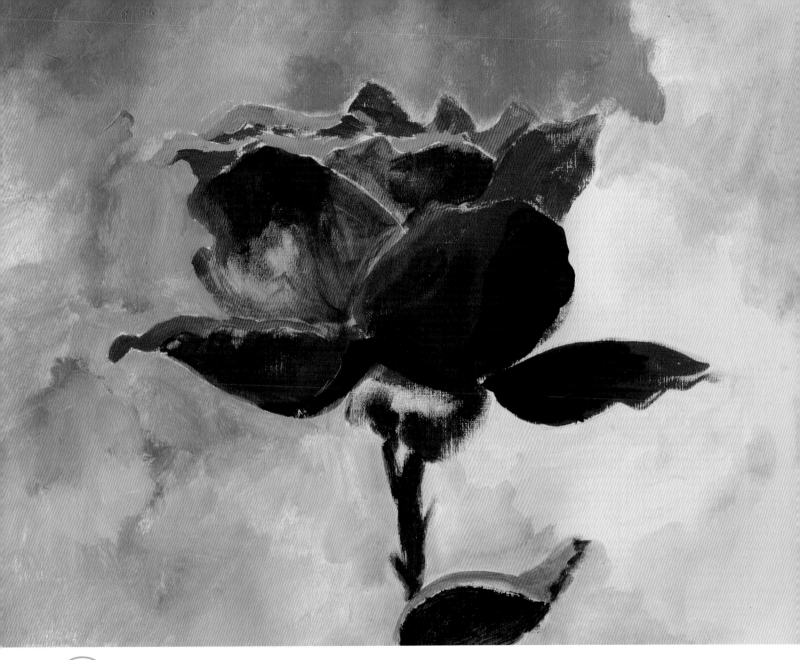

3 We have followed very specific steps in this work that have resulted in a combination of transparent and opaque colors that create relief and luminosity.

Apples: dry brush

This technique requires the use of a hog bristle brush, which is stiffer than a synthetic one. The colors are applied with practically no water, directly and with barely any mixing.

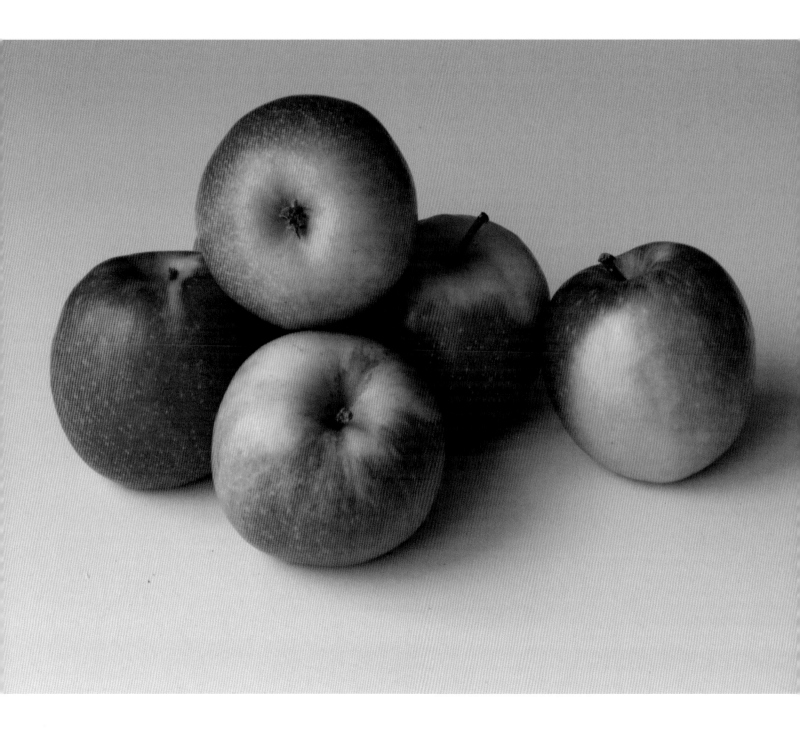

The required colors

The colors used here are almost the same as those in the previous exercise: carmine, permanent red, cadmium yellow, permanent green, and ultramarine blue. We will also add titanium white to the list.

carmine

permanent red

cadmium yellow

permanent green

ultramarine blue

The drawing

The drawing of this subject is very simple: They are just circles indicating each piece of fruit. Each of the circles is similar in size, so achieving correct proportions is not difficult at all.

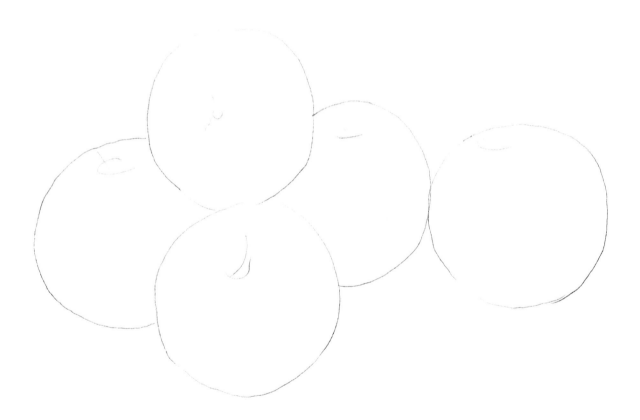

Individual brushstrokes

Since we do not have to work with transparent colors, we can begin applying the color directly. The first brushstrokes define the most vibrant tones and there is no attempt to connect them to one another, like in an Impressionist painting.

1 | We follow the sketched lines with undiluted permanent red brushstrokes.

3 | We lengthen the red strokes until they come into contact with the green, without painting one over the other.

2 | We apply strokes of green mixed with yellow in the places that correspond to the models. The color should be more concentrated than that of the model so we can create an intense harmony from the beginning.

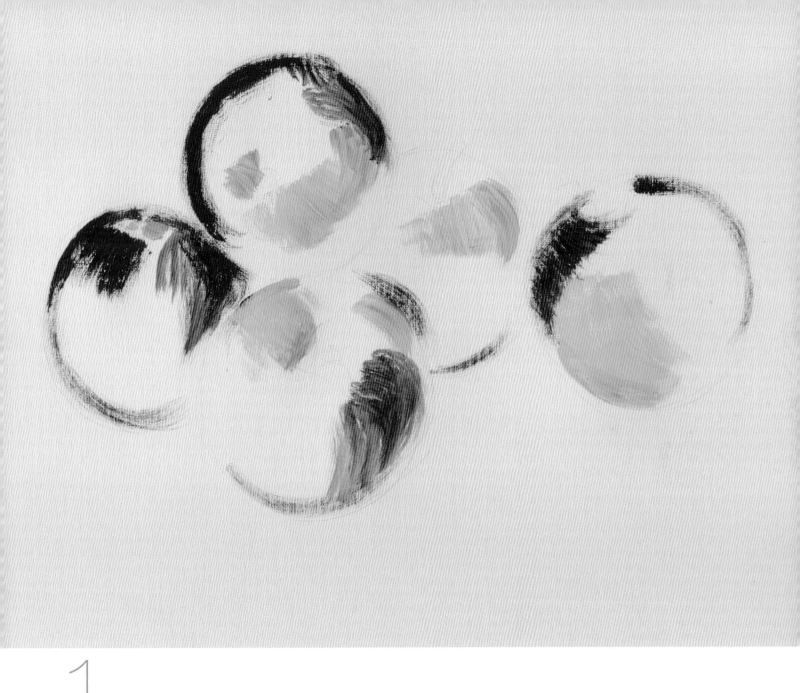

1

We begin to appreciate the roundness of the fruit without the
need for complicated mixtures or color modeling.

Creating the contrasts

Now we will work with the same red and green colors, but with different intensities until the volumes of the fruit are filled in.

1 | We mix permanent red and white to make a pink that will be used as a transition between the saturated red and the light greens.

3 | We apply unmixed green directly to the darkest areas, especially at the points where the apples are touching each other.

2 | We resolve the areas with the most light by brushing gently across the paper or canvas. The effect is typical of the dry brush technique.

4 | This stroke of intense red emphasizes the outline of the closer apple and partially darkens the part of the other fruit that is in shadow.

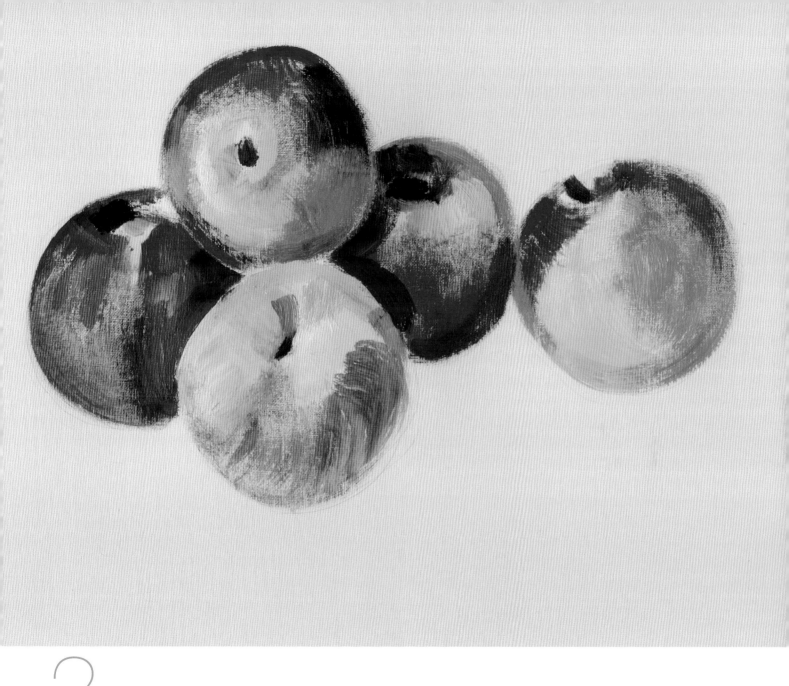

2 We have achieved some beautiful modeling, while barely
gradating the colors, by using the contrasts of pure colors.

The background

Since we wish to highlight the vibrant coloring of the apples, we will create a neutral color background made with blue, some red, a little yellow, and a lot of white.

1 | We paint the background by simply applying the mixed paint while paying attention to the outlines of each piece of fruit.

2 | We darken the shadows projected by the apples, adding a little more blue to the background color.

3 | Finally, we emphasize the outlines using blue with a simple brushstroke to indicate the angle of the plane of the tabletop.

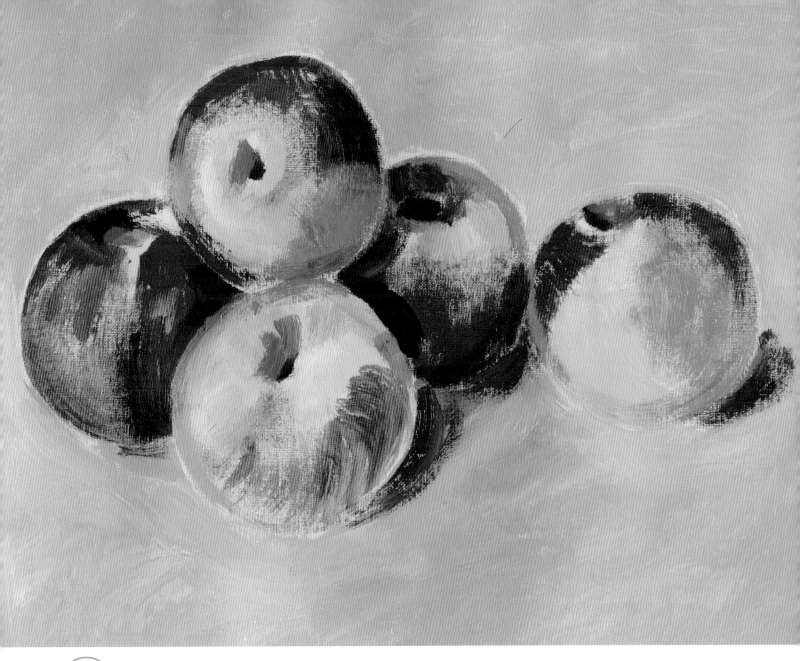

3 The attractive roughness of the skin of the fruit is a result of the characteristic crudeness of the dry brush technique, where it is important to preserve the intensity of the color.

Flower on a dark background:
watercolor

A squirt of acrylic medium should be added to the water so the acrylic paint can be thinned to watercolor consistency without reducing its luminosity. It is important to keep the paint from building up by spreading it with soft synthetic or natural hair brushes, as if it were watercolor paint.

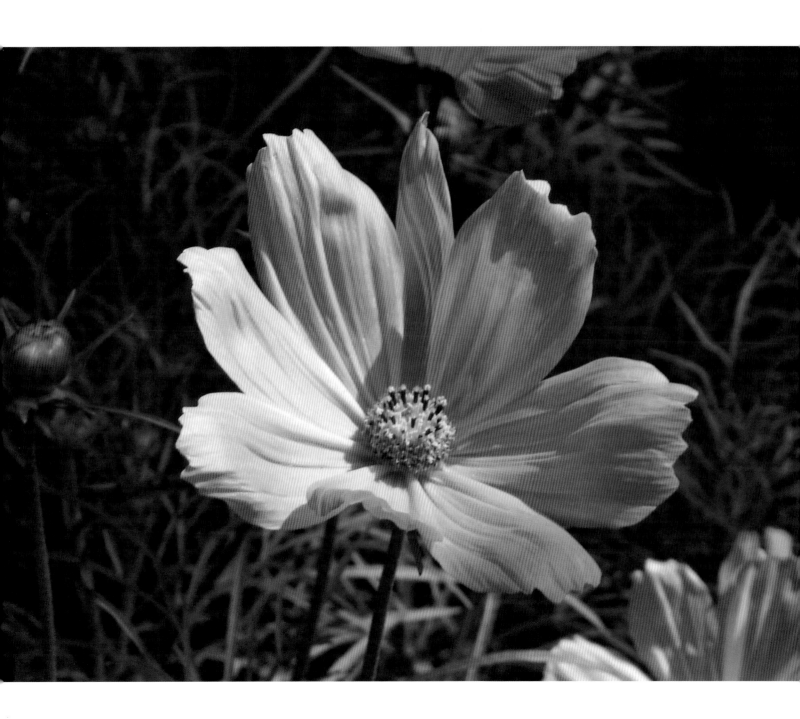

The required colors

The colors used here are lemon yellow, permanent red, magenta, cobalt violet, sap green, and ivory black. To these we must add, as always, titanium white. In addition we will use a little acrylic medium mixed with water.

lemon yellow

permanent red

magenta

cobalt violet

sap green

ivory black

The drawing

This is an easy drawing, with large wide shapes. The details of the flower can be represented with little difficulty. Besides, any possible flaws in the drawing are more acceptable in plant and floral themes than in other subjects.

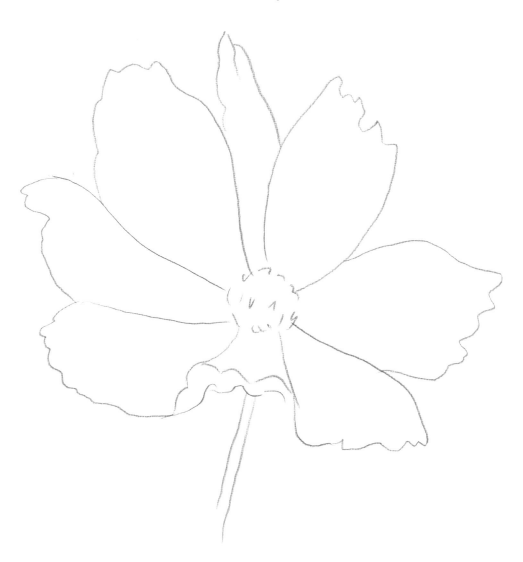

Painting the flower petal by petal

The secret is in covering the areas of each petal with magenta diluted with water. We must work slowly, and the support should be held at a more horizontal angle than vertically.

2 | We extend each new brushstroke by adding more water. In the first strokes it is better to use too much water than not enough.

1 | We outline the shape of each petal and then they are filled in by spreading the brushstrokes toward the center.

3 | The first, darkest shadows are drawn with a medium round natural hair brush, which will differentiate the petals from each other.

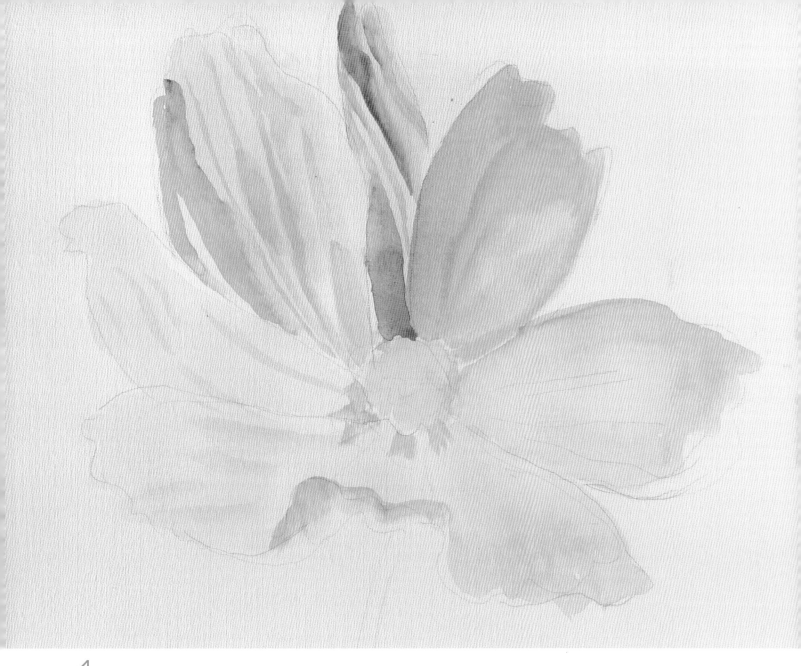

1 The flower is now covered with a light tone that is barely visible in some areas. This light tonality will greatly help us in the next stage.

Light and shadow

To finish the flower, we just have to reinforce the shadows that were lightly indicated in the previous stage. Essentially, it is a matter of looking for the contrasts.

2 | As the paint is spread the brushstrokes become lighter. It is best to wait for them to dry and then paint over them again to darken them.

1 | We paint the darkest petals with the same base color, but less diluted than before so the tone is more intense.

3 | The darkest areas should be painted with the color diluted just enough to make the creamy paint more liquid.

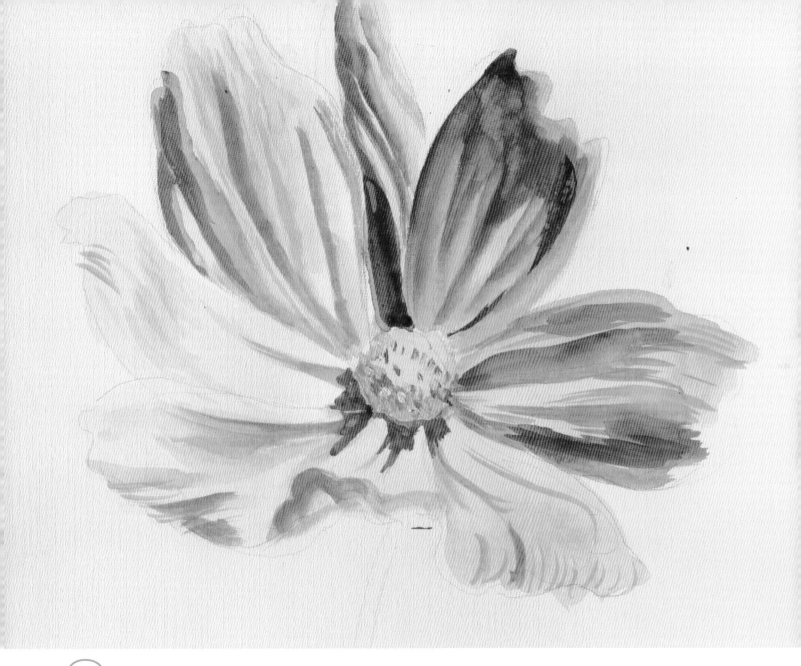

2 The corolla was painted with a saturated yellow for the
shadows and touches of pink to create the relief. The
flower is already finished.

Final contrast

To create a luminous finish, the silky tones of the flower are contrasted with a very dark and much less subtle background.

2 | The color is darkened more and more as the strokes of transparent color accumulate. These should be applied in all direction to suggest grass and leaves.

1 | We paint the background with sap green, a transparent color, following the outlines of the flower.

3 | A single brushstroke of thick paint is enough to create the stem of the flower.

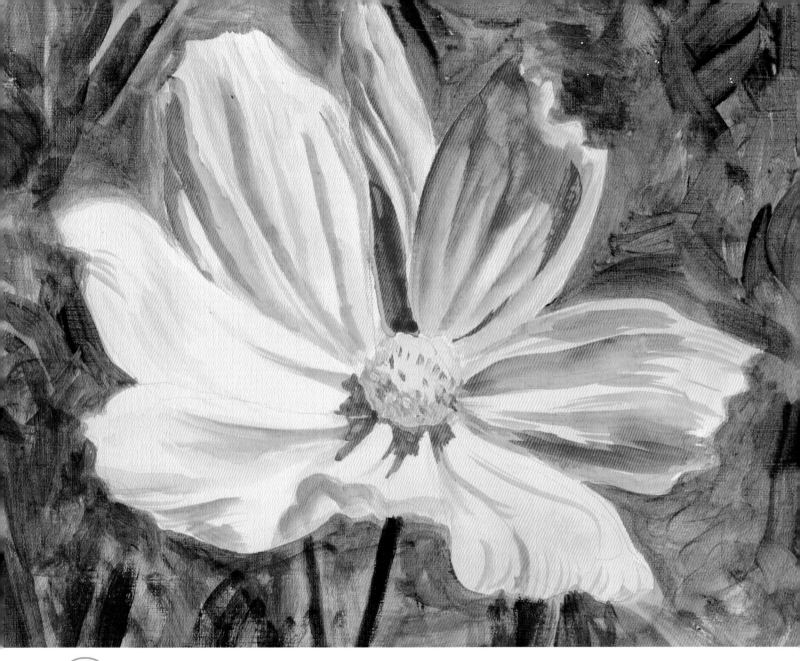

3 This painting is fairly easy to make and very striking. It combines the transparency of watercolors and the strong color of acrylic paint.

A tied boat: color impasto

Although it is not a particularly difficult technique, impasto demands some daring. This technique requires the use of wide brushstrokes and the brushes loaded with paint. If you begin by using paint that is not too thick, it will be easier to shift to impasto in the second stage of the work.

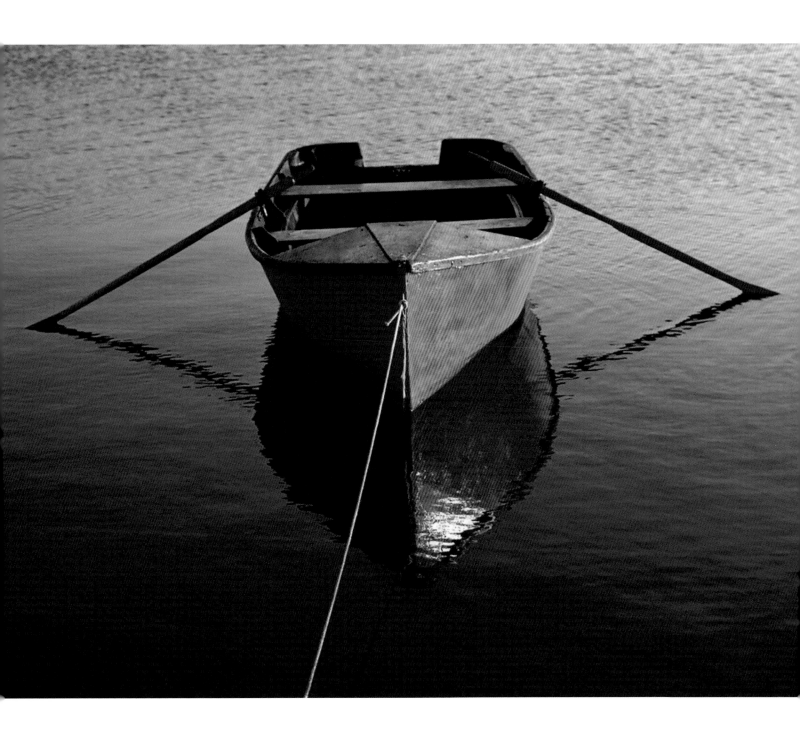

The required colors

The colors used in this exercise are lemon yellow, yellow ochre, burnt sienna, carmine, cobalt blue, and ultramarine blue. Titanium white should also be added to the list.

lemon yellow yellow ochre burnt sienna

carmine cobalt blue ultramarine blue

The drawing

The boat has an almost symmetrical shape and is relatively easy to draw. It should be centered on the support and not be drawn too small, since the wider the areas that are to be painted, the easier the impasto work.

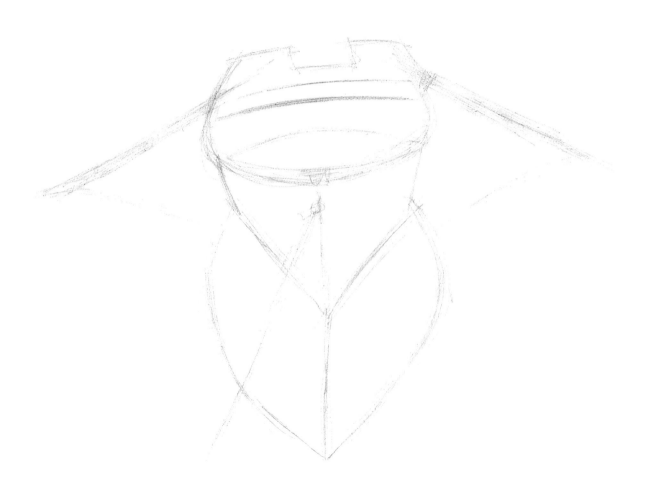

First brushstrokes

We paint over the sketched lines with dark brushstrokes to simplify them as much as possible. The first applications cover each shape in the drawing up to the edges marked by the lines.

1 | We divide the drawing into simple areas that will contain the colors by retracing the pencil lines with wide brushstrokes of cobalt blue mixed with burnt sienna.

3 | Here we paint with a mixture of carmine, burnt sienna, and yellow. The color is dense and it is a bit difficult to cover the roughness of the canvas, so we must press hard and rub it in.

2 | We paint directly with pure colors, just as they come from the tubes, right up to the edges of the drawing.

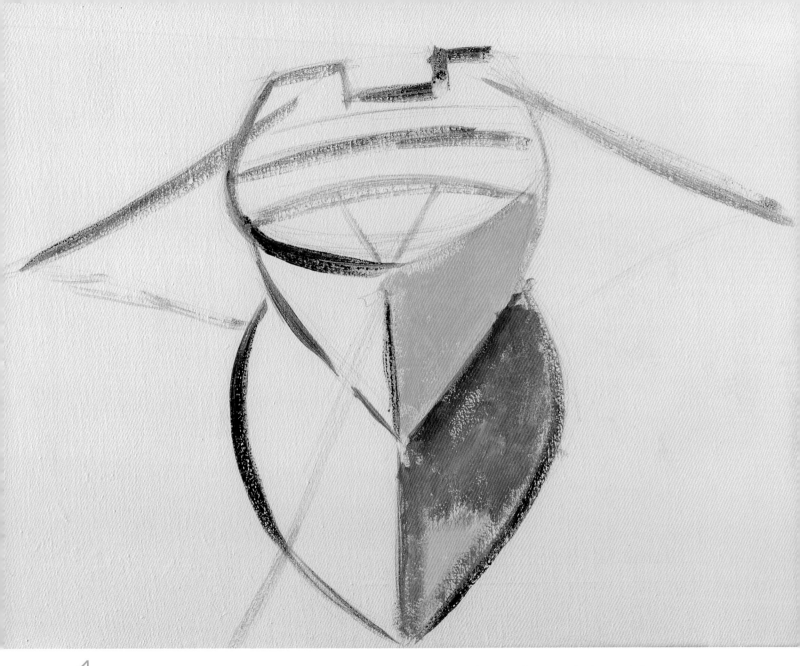

1 The reflections are always darker than the colors of the objects. The reflected colors will therefore be a darkened version of the colors on the boat.

Few brushstrokes

Interesting impastos are a result of the energy used in painting them and the simple and economic way the paint was applied. A few clearly defined brushstrokes are better than many brushstrokes that create an area of uniform color.

2 | We paint the deck with slightly thinned color to make it easier to apply to the small spaces with the brush.

1 | The darkest colors are painted with a mix of burnt sienna, yellow, and ultramarine blue. The brushstrokes are thick and just a few are enough to cover each area.

3 | We paint the surface of the water with a wide flat brush, leaving very visible brushstrokes.

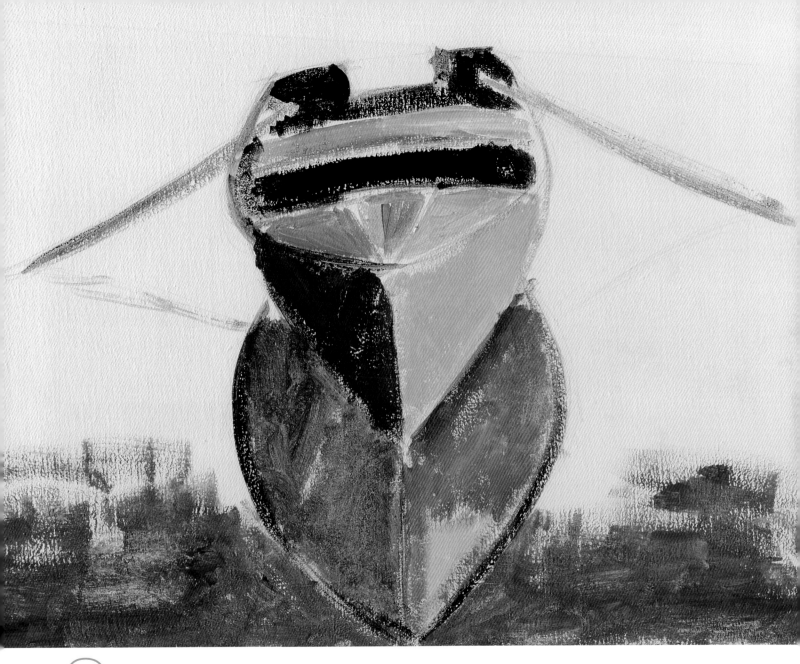

2 The boat needs just a few finishing touches. The rhythm of the work is very fast and the colors are emphasized by the texture of the brushstrokes.

The movement of the water

The movement of the water can be represented by following very simple steps using paint and drawing techniques. Let's take a look.

1 | We apply the ultramarine blue, which is darker than the cobalt blue, in the lower area with random brushstrokes that suggest waves.

2 | In the upper area we spread paint very diluted with water to create the chiaroscuro contrast that emphasizes the sense of space.

3 | A wavy line on the boat's outline is enough to create the illusion of waves. The thick line is a mixture of ultramarine blue and burnt sienna.

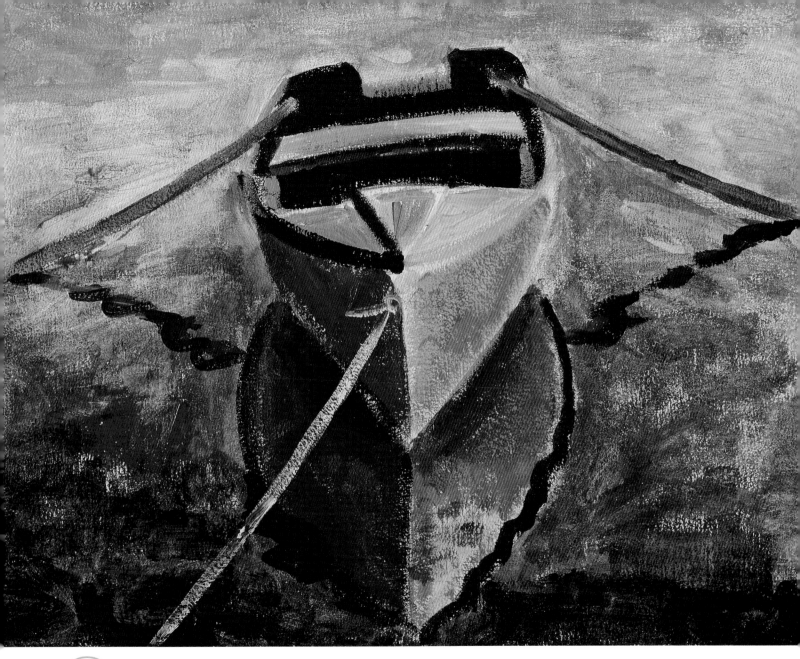

3 The rope that ties the boat is a simple stroke of white paint over a completely dry base. The resulting textural effect reinforces the expressivity of the work.

A tree in autumn:
simple masking

This painting requires masking tape reserves to create the background of the composition. The subject itself is also going to be masked, but in a direct manner without complicated steps.

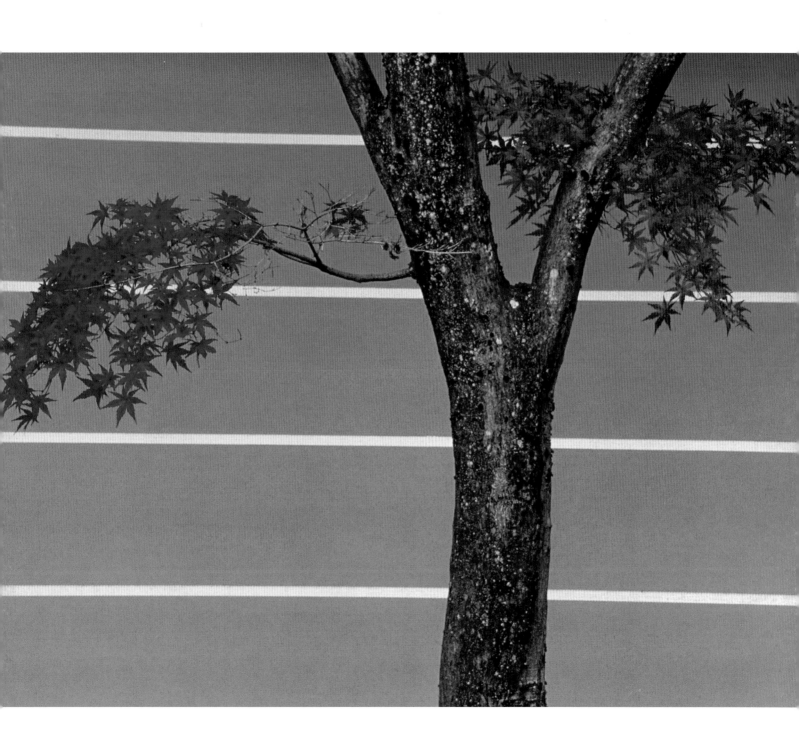

The required colors

The colors we will use are yellow ochre, cadmium orange, carmine, permanent green, and ivory black. Titanium white must also be added to the list.

yellow ochre

cadmium orange

carmine

permanent green

ivory black

The drawing

The hardest part of this drawing is painting the leaves. They can be indicated with generic lines that will later be finished with brushstrokes when the details are added.

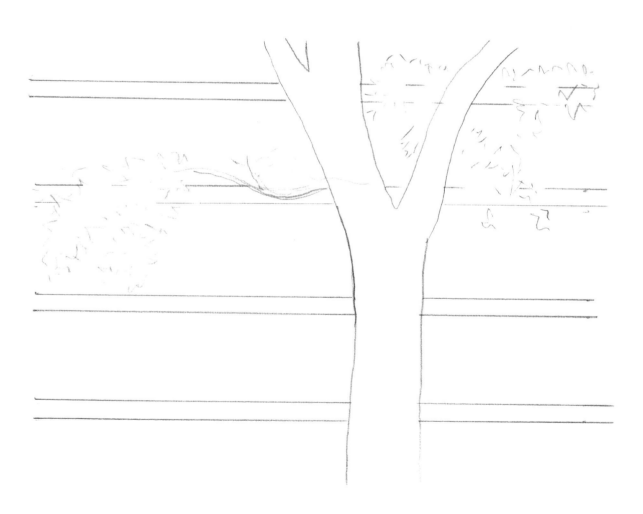

Masking with tape

We will use strips of paper masking tape cut in half the long way to make them thinner. They will then be put on the support, making sure they adhere completely. Once this preparation is complete, we can begin to paint.

1 | After the strips are stuck to the support we paint directly over them with yellow ochre, making sure that the paint covers their edges.

3 | We use thick, dense paint to create a solid and opaque surface.

2 | We cover the whole space except for the tree and leaves.

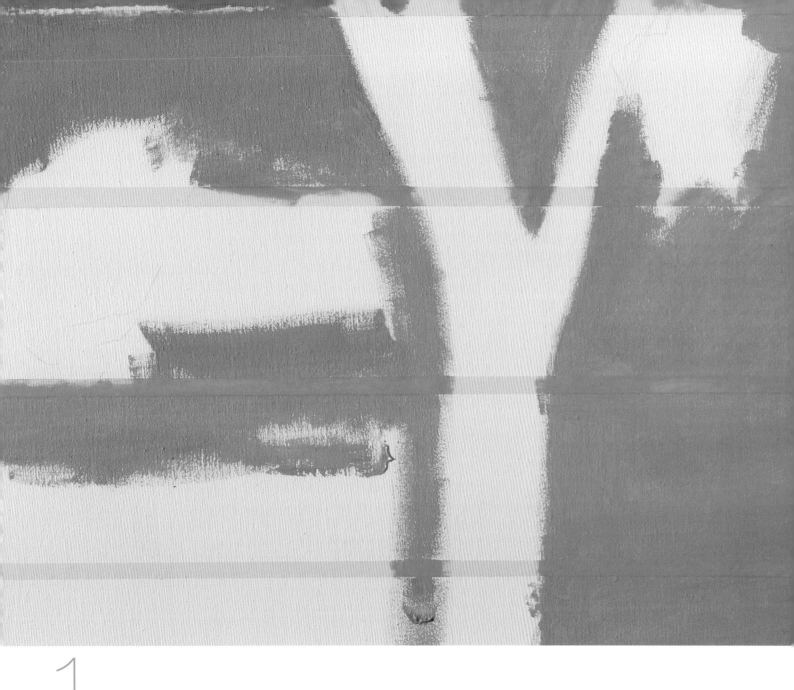

1 The white areas correspond to the trunk and leaves of the tree.
The white background will make the painting easier.

Modeling the trunk

First we paint with a very diluted black to achieve a wide variety of tones. Then we repaint the darkest areas with opaque color.

1 | After the background is painted—and when the paint has dried—we remove each strip of masking tape.

2 | We apply the black—which is initially very diluted with water—to create transparent shades.

3 | We add shadows to the transparent tones with a more opaque black to create the effect of volume on the trunk.

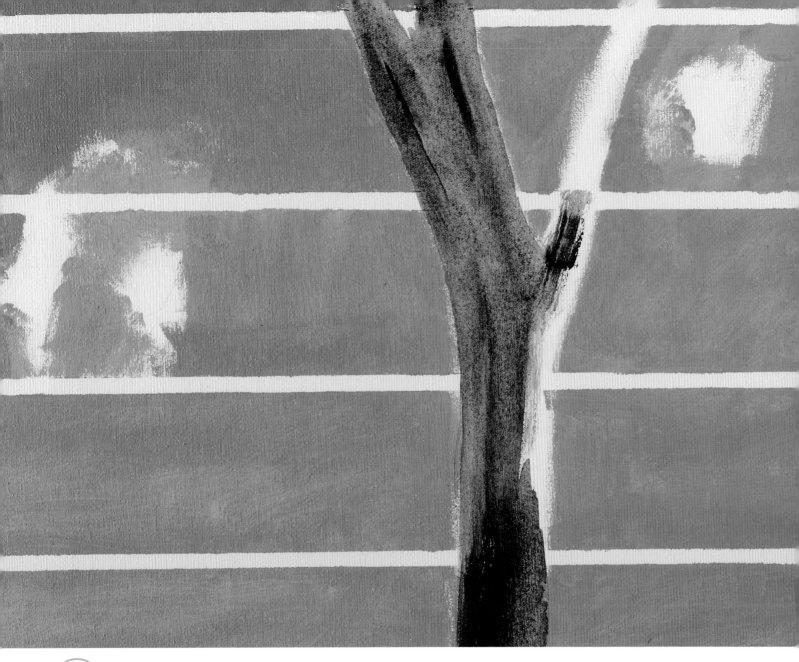

2 The contrast between the transparent parts and the opaque parts adds relief to the tree trunk, which stands out very clearly from the ochre wall in the background.

The colors of the leaves

The lively colors of the leaves are created by applying pure colors, only mixing them when it is necessary.

1 | We apply cadmium red with the tip of the brush. This one is flat and makes marks shaped like dashes that are used to build up the leaves.

3 | This very thin branch must be painted with a round natural hair brush to make a sensitive flowing line.

2 | We paint the darkest leaves green mixed with a little red, always working with the tip of the brush.

4 | Carmine comes into play in this group of leaves. The applications of red and carmine should be superimposed here, but not mixed.

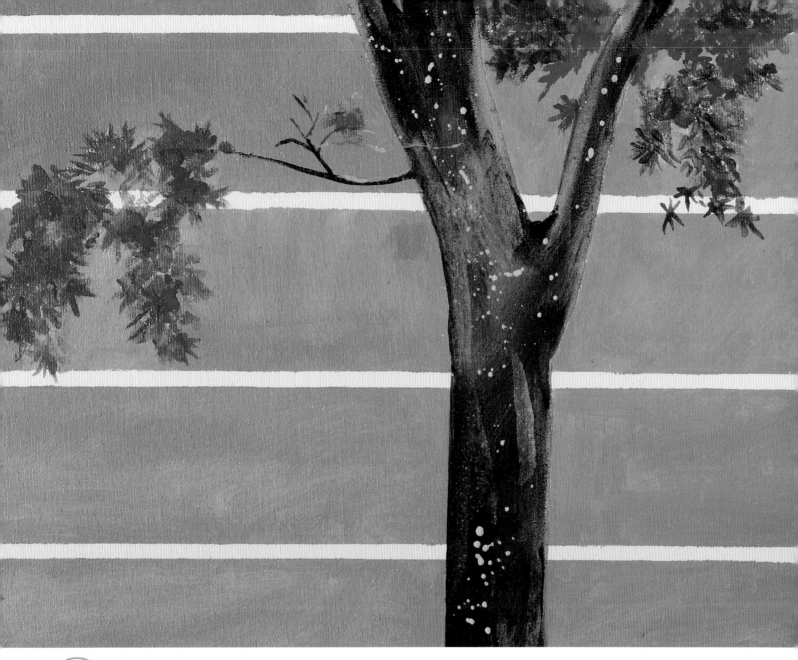

3 To finish the tree we applied some small dots of light green paint to represent the moss that covers the trunk. The result is simple and attends to detail.

A flamingo:
blending color

Conventional gradations of color, going from light to dark or dark to light in a continuous progression, is not difficult when painting with acrylics. However, it requires working quickly.

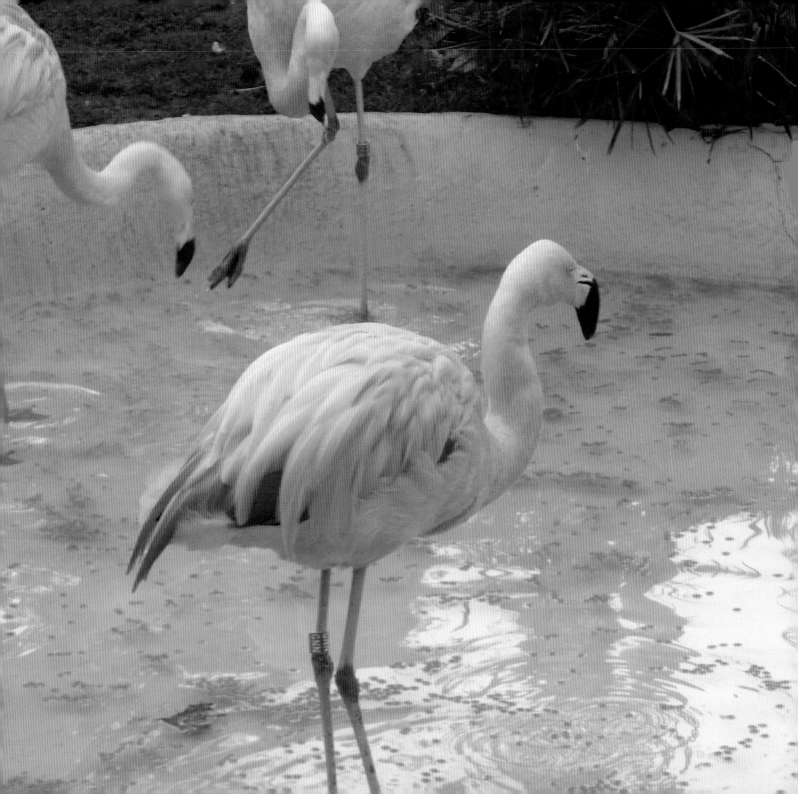

The required colors

The colors used for this painting are magenta, cobalt blue, cerulean blue, lemon yellow, and permanent green. As always, titanium white will be one more color on this palette.

magenta

cobalt blue

cerulean blue

permanent green

lemon yellow

The drawing

The drawing of the bird was made with lines that approximate the shape of the body and its position in the water of the lagoon. The lines will be completely covered by the paint.

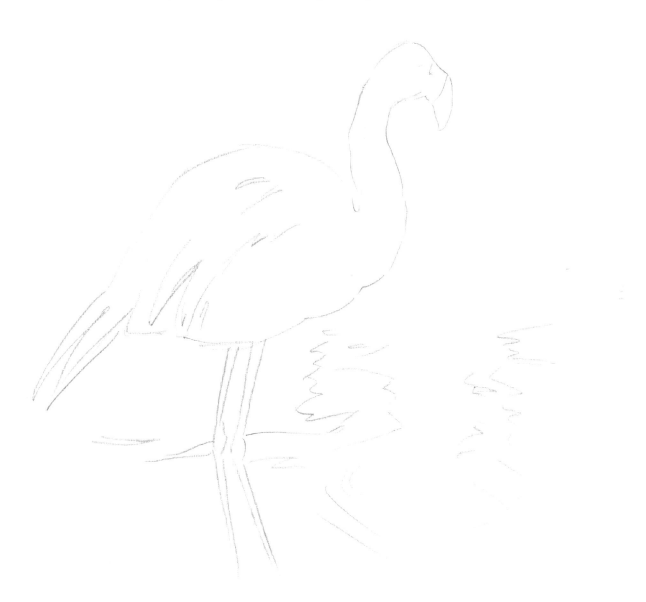

The flamingo's plumage

This pink plumage can be painted with a mixture of magenta and white. A small amount of cobalt blue will be used in the most shaded areas. It is important for the brush marks to be clearly distinguishable.

2 | The plumage on the shoulder of the bird is much lighter. The brushstrokes here should be very long.

1 | We will mainly use magenta mixed with white. The darkest tones have a smaller amount of white and the mauve tones contain a small amount of blue.

3 | In the parts with the most light the brushstrokes should be almost white.

The volume of the flamingo's body can clearly be seen because of the alternating brushstrokes with different tones that create relief and represent the plumage.

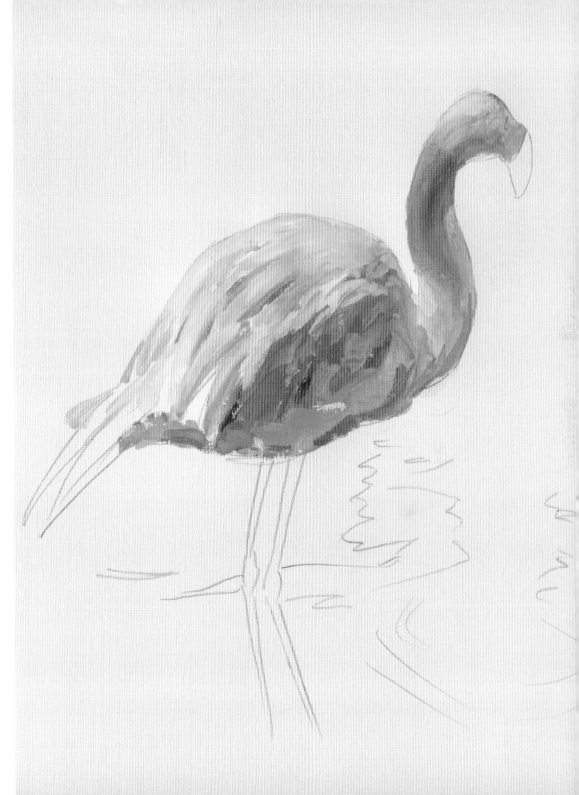

1

Finishing the flamingo

The finishing details of the flamingo are very simple but important, since they identify this stylized bird.

1 | The red feathers of the tail are strokes of pure paint applied quickly and decisively to achieve straight lines.

2 | The legs are dark strokes that form a very slight angle.

3 | One dark brushstroke of blue mixed with red should be enough to define the shape of the beak.

The flamingo is
finished but the
background still
has to be resolved.
Its color is as
important as the
order of the
brushstrokes.

2

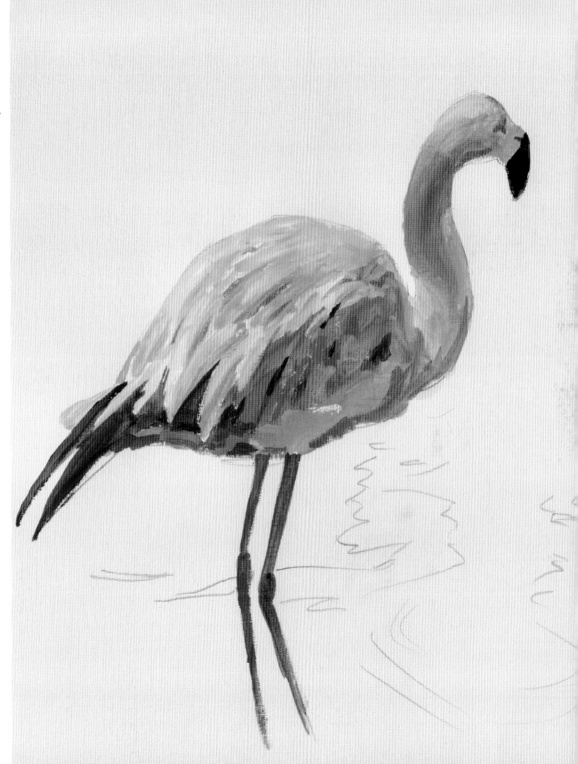

Blending the color of the water

Gradating and blending the color is done by working from light to dark. We must paint quickly to avoid those brushstrokes that dry before they can be blended with other lighter ones.

1 | We apply thick brushstrokes of unmixed cobalt blue to the upper part of the composition.

2 | As we work our way towards the lower part of the paper, we add white and a little lemon yellow to the previous color and immediately mix it with the first brushstrokes so we can prevent abrupt changes of color.

3 | We use cerulean blue mixed with quite a bit of white at the bottom of the painting to create a very light and luminous bluish tone.

The blue
background
creates a very
bright contrast
with the pink
plumage of the
flamingo and adds
an appropriate
context to the
theme.

3

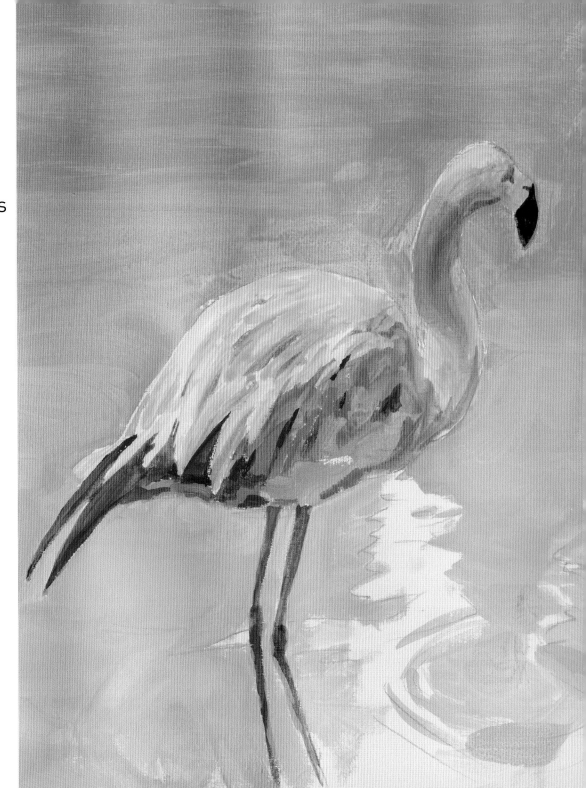

The surface of the water

When the transparency of the water is not being represented we must use other approaches, like indicating reflections, so that the depiction of the water will be convincing.

1 | The lightest tones are reflections of the sunlight. The shapes of the brushstrokes must create the effect of waves.

2 | A few thin lines can suggest reflections that are disappearing among the ripples on the surface.

3 | We should use the smallest brush we have for these reflections and a color so light that it is almost white.

The process
was slow at the
beginning and
fast at the end.
Gradations made
with acrylic colors
should not slow us
down if we want
results that are
light and not
overworked.

4

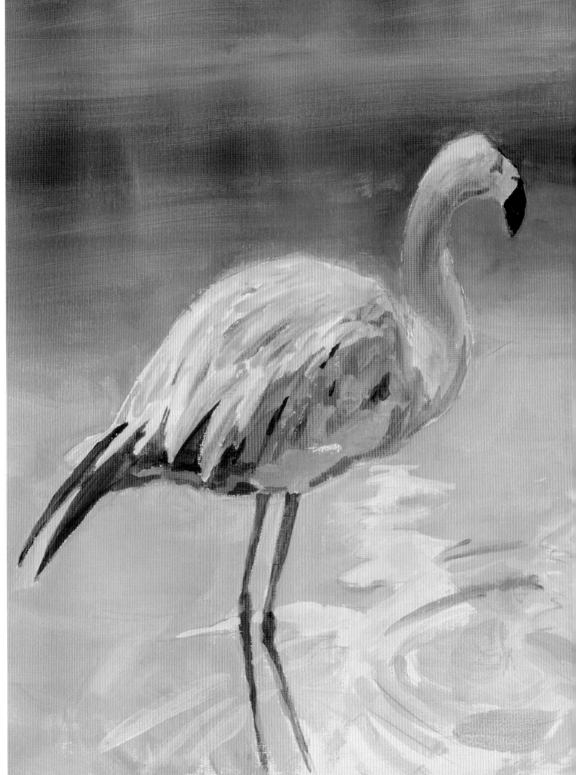

Branches and a flower:

complex masking

Reserves made with masking tape create graphic and artistic effects at the same time. The results are modern and attractive. In this exercise we will see how the reserves can be taken farther than a few simple white lines.

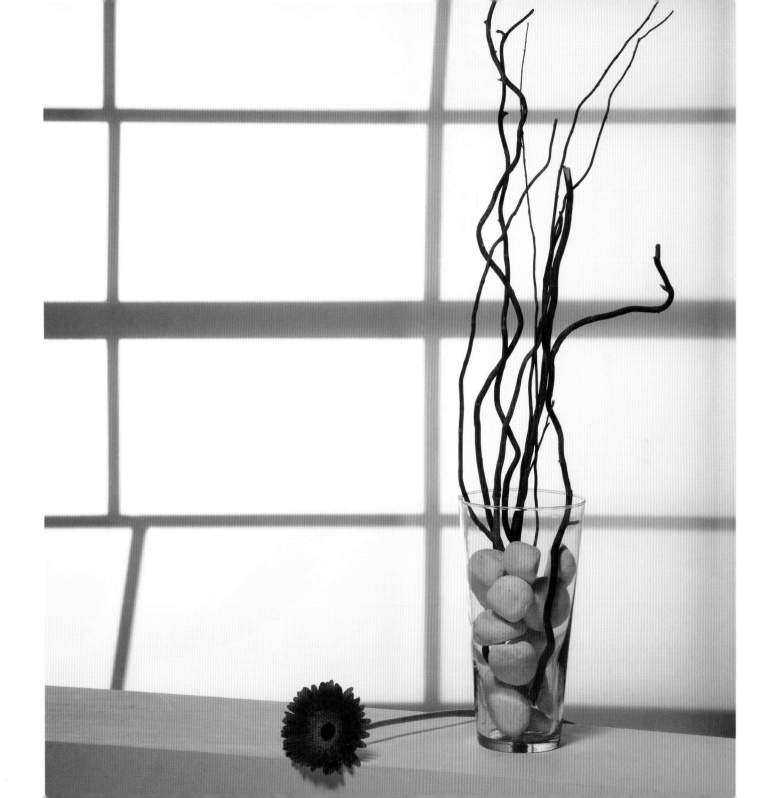

The required colors

The colors used here are yellow ochre, burnt sienna, sap green, lemon yellow, magenta, and ivory black, and of course, titanium white.

yellow ochre

burnt sienna

sap green

lemon yellow

magenta

ivory black

The drawing

This drawing should be made with a soft pencil and then sprayed with a fixative so that it will remain visible under the first layer of paint. If necessary it can be retraced over the paint layer.

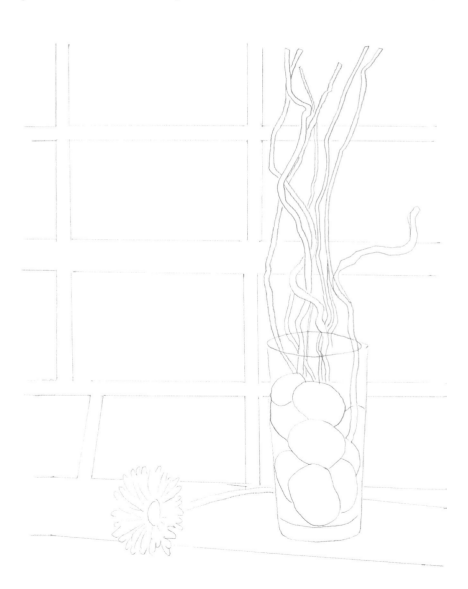

Masking the background

This theme requires careful work making the reserves that construct the geometry that dominates the background of the composition. The success of the final piece will depend on this preliminary work.

2 | The horizontal bands are masked first and we paint between them with a dark gray.

1 | We first paint the paper with a light gray gradation over which everything else will be painted.

3 | The vertical bands follow, which we paint when the first ones are completely dry.

This is the
finished
background. The
drawing was
retraced on this
base so it could be
painted without
difficulties.

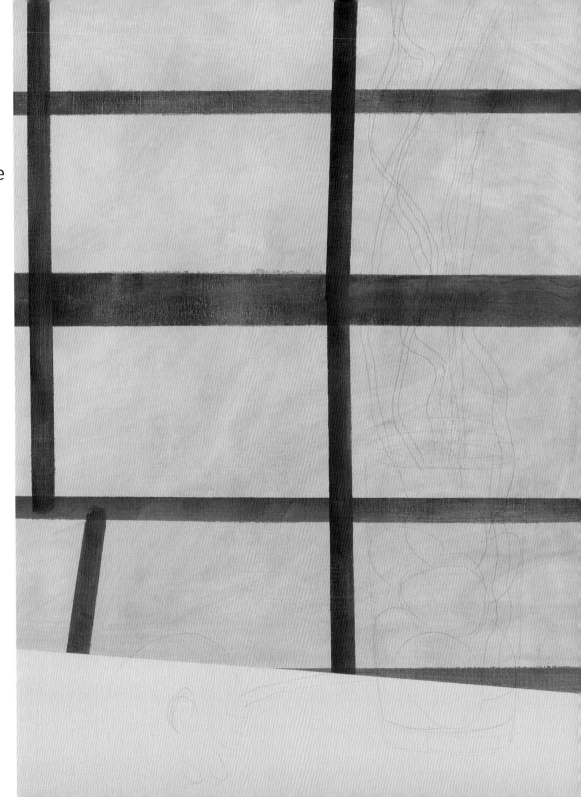

1

The stones

The stones are gray, a warm gray made by mixing ochre, burnt sienna, a small amount of black, and a lot of white. These are the colors that will be used, but the proportions of each color will be varied as we paint.

2 | The projected shadows are the same gray as before, a little darker, painted to emphasize the volumes of the better lit stones.

1 | We have painted each stone with pale ochre and then shade it with gray.

3 | We paint the lightest areas with a very light gray that stands out from the gray in the background because of its warmer tone.

These "floating" stones are already finished. We can almost see the vase without having painted it.

2

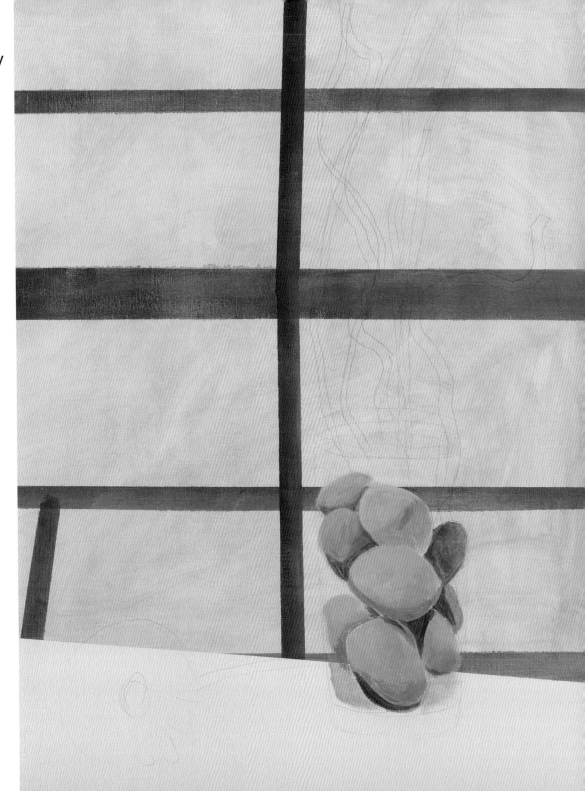

The vase and the branches

The vase requires just a few brushstrokes. The branches will not be a problem since the angles and curved shapes can be changed without making them look less real.

1 | We only need to paint the lip and the base of the vase. The first is a simple ellipse that can be painted with a single gray line.

2 | The greenish color of the base suggests the thickness of the glass. It should be painted with contrasts to express its shininess.

3 | Painting the branches is as simple as drawing long lines with the tip of the brush. We must only be careful to maintain the constant thickness of each branch.

Synthesis is the key to representing the glass and the branches, by displaying the various parts of the object as a whole.

3

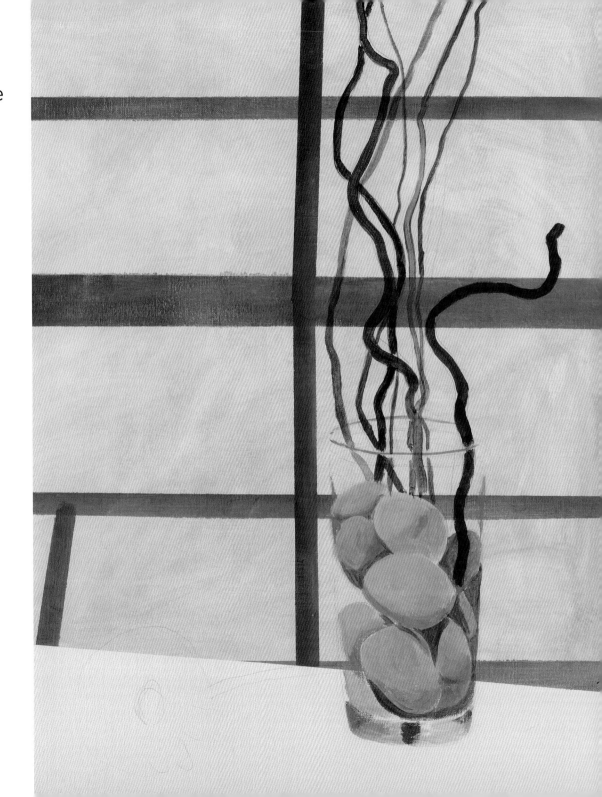

The flower and the final details

The reds of the flower will add the necessary chromatic contrast to the harmony of light colors used in the painting. We paint the flower petal by petal, carefully following the shape of the drawing.

1 | We keep the area white where the flower will lay. This will make the color brighter as we paint each petal at a time.

2 | We are careful to paint around the flower to avoid covering any of the petals. After finishing the flower we reserve the ochre band.

3 | Finally, we shade the lower part of the table on which the vase and flower repose.

The few elements have great presence because of their careful and detailed treatment. There is a harmony of light colors and pure forms.

4

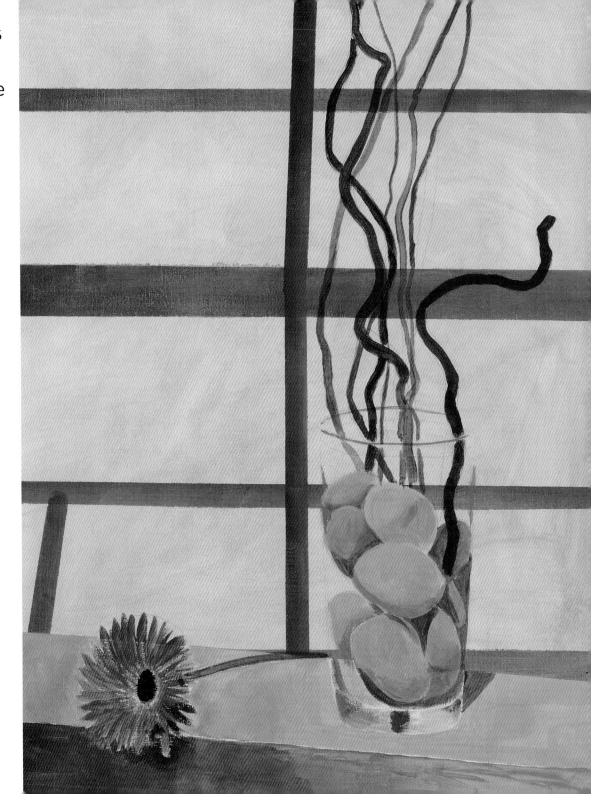

Original title of the book in Spanish: *Acrílico una nueva forma de aprender a pintar*
© Copyright 2009 PARRAMON EDICIONES, S.A.,—World Rights
Published by Parramón Ediciones, S.A., Barcelona, Spain

Author: Parramón's Editorial Team
Project manager: Maria Fernanda Canal
Editor: Mª Carmen Ramos
Text and Coordination: David Sanmiguel
Exercises: David Sanmiguel, Óscar Sanchís
Graphic Design: Soti Mas-Bagà, Pilar Cano
Three Dimensional Design: Pere Duran
Photography: Parramón Archives, Nos & Soto
Production Manager: Rafael Marfil
Production: Manel Sánchez
English translation: Michael Brunelle and Beatríz Cortabarria

All inquiries should be addressed to:
Barron's Educational Series, Inc.
250 Wireless Boulevard
Hauppauge, New York 11788
www.barronseduc.com

ISBN-13: 978-0-7641-4549-0
ISBN-10: 0-7641-4549-5

Library of Congress Catalog Card No. 2010924253

Printed in China
9 8 7 6 5 4 3 2 1

MATERIALS
Acrylic

Colors

Acrylic paints are pigments agglutinated with synthetic resin, a polyvinyl acrilate emulsion. The emulsion dries by evaporation of the water to form an elastic film that is transparent and very durable. The elasticity, transparency, and durability are advantages, along with the fast drying time that characterizes acrylic paint.

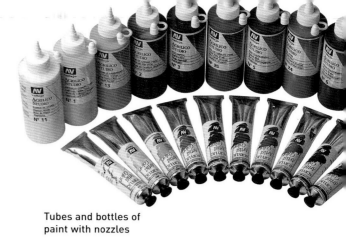

Tubes and bottles of paint with nozzles

Matte and glossy paint
Dry acrylic paint has a satin surface that can be matte or glossy according to the particular paint. Any color can be found in either version, since the only difference is the acrylic medium, not the pigment. Manufacturers offer both versions. It is typical to use glossy paint if you wish to work with large impastos.

Formats
Acrylic colors are sold in two formats, in tubes and in containers. The tubes are usually the same sizes as the tubes used for oil paints. The containers can be of different shapes and sizes, from small ones with nozzles to buckets holding a gallon.

Large containers of paint with wide tops

Transparent and opaque
Acrylic colors can be diluted with water until they can be used to make very light color washes very similar to watercolors. When used with less water or right out of the tube they are much more opaque. Certain colors (carmine, burnt sienna, emerald green, sap green, etc.) can only be completely opaque if they are mixed with a little white or if they are applied in successive layers.

The colors must be very well mixed

Care when mixing
Acrylic paint is easy to manipulate, but we must be careful when mixing colors on the palette, since we may think we have mixed the colors well when they may not be totally homogenous. Streaks of different colors are typically seen in brushstrokes of paint that has been mixed on a palette, indicating insufficient mixing. This occurs more often in acrylics than in oils, whose viscosity encourages easy incorporation of one color into another.

Mixed techniques
Acrylic paint has become an "all terrain" medium that can be combined with many others. It can be combined with gouache, with pastels, or it can serve as a universal base for most painting media. All the mixed media will be stable as long as there is no oily component (oils, waxes, oil varnishes, etc.), which will greatly deteriorate the paint layer and cause it to flake off the support.

Acrylic paint can be used for many mixing techniques

Recommended colors
The ideal would be to have as many colors as possible because acrylic paint is always cleaner when it is applied without mixing. But you should always have titanium white and ivory black as indispensable colors. In the yellow range a cadmium lemon yellow would be enough. Among the reds you should have cadmium red, carmine or magenta, and a scarlet red. The important earth colors are yellow ochre, burnt sienna, and burnt umber. Among the blues, cobalt and ultramarine are very useful, as well as cobalt violet. Finally, permanent green and sap green are the most recommended.

Brushes

Acrylic painting does not require specific brushes and it can be manipulated with any applicator that is neither too hard nor too soft. Any applicator must be very clean since the paint is practically indestructible after it has dried.

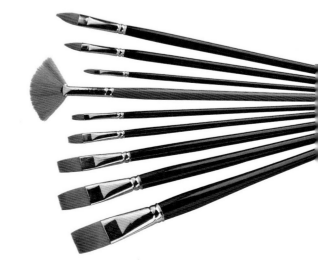

Natural bristle brushes

Bristle brushes
The bristle brushes used for oil painting may also be used for acrylics, but sometimes the bristles are too stiff for paint that has less body than oils. This can be the case when working with diluted paint making washes, transparencies, or light blending. In these cases it is better to use brushes with softer hair.

Watercolor brushes
These are especially practical for working with very diluted paint and also when you wish to apply minute detail that can only be done using the fine tip of a natural sable brush. Generally, natural hair watercolor brushes are too soft and lose any stiffness when used with thick paint.

Synthetic hair brushes
The narrow and thin brushes are useful for doing small and detailed work that requires fine line work; these can be used along with natural bristle brushes. The larger sizes are best for use with acrylics, since they carry a lot of paint, even when it is undiluted, and maintain the right combination of stiffness and flexibility that is needed for applying large layers of paint and heavy impastos.

Synthetic hair brushes

Cleaning brushes
Fast drying acrylics make it important to keep brushes in water for the duration of the working session and to carefully wash them afterwards. If the paint dries in the hair or bristles, they will separate and begin to look like a broom, making them ineffective. It is best to keep the brushes in water while working and wash them with soap and water when finished.

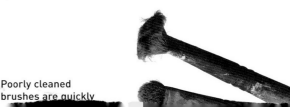

Poorly cleaned brushes are quickly

Recommended brushes

It is important to have a variety of bristle brushes, especially in large and small sizes. For the mid sizes it is best to have flat and round synthetic hair brushes.

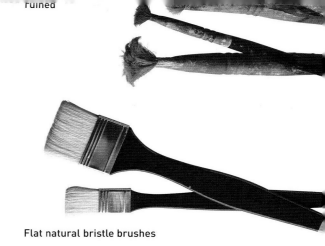
ruined

Flat natural bristle brushes

Supports

Acrylics can be applied to any non-greasy surface. This is one of their great advantages, since the support barely requires any preparation. However, the best results can be achieved painting on surfaces and materials that have been properly prepared.

Canvases

Canvas is the most usual support for acrylic paints as long as the techniques used are similar to those used for oils. The ones sold for use with acrylics are made of linen, cotton, or synthetic fabrics. Cotton canvases are the best quality for the price; however, the surface preparation must be specifically for acrylics because the preparations used for oil paint will keep the acrylics from adhering to it.

Wood

Wood panels are good supports for acrylic paint, but they require a good preparation on both sides, after a good sanding, to prevent the board from warping. In addition, it is a good idea to attach the board to a stretcher to strengthen it. It is prepared just like fabric; several coats of an acrylic base (also known as acrylic gesso) will be enough. Plywood and MDF (medium density fiberboard) are used most because they are stiff and durable.

Cardboard

Cardboard must be prepared before painting on it with acrylics, unless they are canvas covered panels like those made for oil painting. Cardboard is very inexpensive and easy to work with; the exception is that humidity causes the thicker ones to warp.

Paper

This is the least expensive support for painting with acrylics. It should be somewhat heavy, at least 140 lb. (300 grams per square meter) and have a little texture so the paint can adhere to it. Watercolor paper is very good for this, although some artists feel it is too absorbent. Applying a coat of acrylic base to the surface of the paper will take care of this problem.

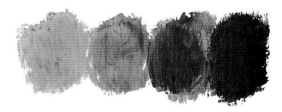
Acrylic on canvas

Acrylic on wood

Acrylic on paper

Auxiliary Materials

Acrylics are direct and very simple to use. Almost any surface can be used as a palette and the painter can use as many or as few accessories as he or she wishes. There are a great number of additives available; here are some of the more popular ones.

Acrylic medium

Acrylic medium, the agglutinate of binder of the paint, is the most common additive. Added to water it improves the consistency and flexibility of the paint. It is very useful when working with very diluted paint, because too much water can affect the transparency and color of the paint.

Retarder

This is a viscous liquid or transparent paste that is added in very small amounts to mixtures to make the paint dry more slowly. It is used by artists accustomed to the slow drying time of oil paints, who wish to modify the paint on the canvas by blending and direct mixing.

Gel

This is a transparent paste with several different applications. The most common is adding body or thickness to impastos that will not shrink when they dry. It can also be used for glazing when mixed with a little color. Many artists who work with collages use gel as an adhesive.

Palettes

You can use the same kind of palettes that are used for oil painting, but remember that leftover paint that dries on them cannot be removed or reused. This can be a serious problem, because after a while the built up paint will interfere with the mixing process. In addition, the partially dried bits of leftover paint will be transferred to the canvas looking like small scales, and they are very difficult to remove.

Other surfaces for mixing

The previous shortcomings can be avoided by using disposable palettes, which are tablets of waxed paper, or (the most inexpensive route) working on plastic, tile, glass, or marble. These materials are nonporous and very smooth and can easily be cleaned with a scraper or palette knife after the painting is done. Plastic palettes (usually acrylic) wear out sooner because they are easily scratched. Ceramic tile, a piece of marble, or a thick sheet of glass are the best options for working in the studio.

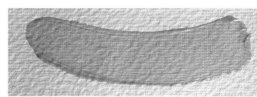
Acrylic medium increases transparency and fluidity

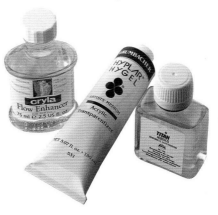
Additives for thinning paint, making it more transparent, and slowing its drying time

Gel allows the creation of translucent textures

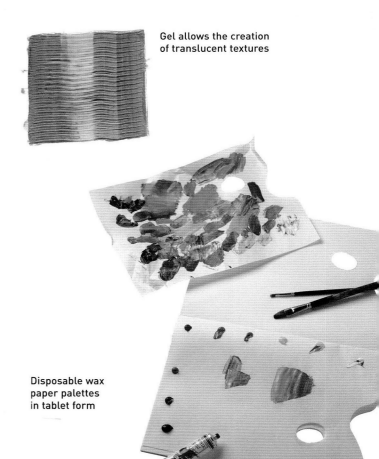
Disposable wax paper palettes in tablet form